Quotable Dogs

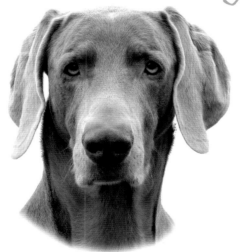

summersdale

QUOTABLE DOGS

Summersdale Publishers Ltd
46 West Street
Chichester
West Sussex
PO19 1RP
UK

www.summersdale.com

Printed by Imago

All images © Shutterstock

ISBN: 1-84024-537-9
ISBN: 978-1-84024-537-0

Quotable Dogs

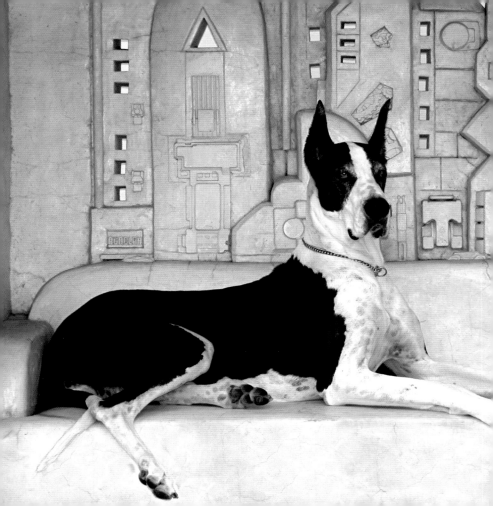

A dog is not **almost-human**, and I know of no **greater insult** to the canine race than to describe it as such.

John Holmes

My **little** dog – a heartbeat at my **feet**.

Edith Wharton

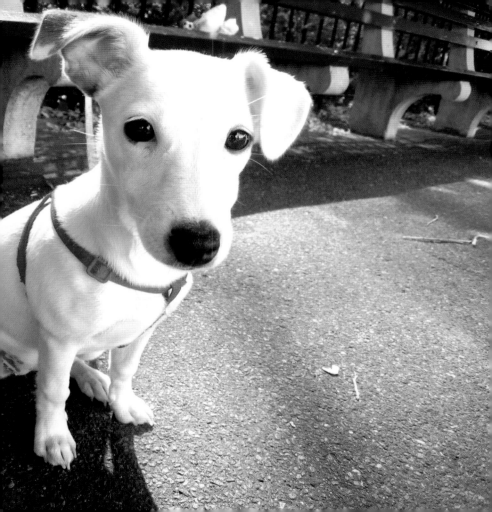

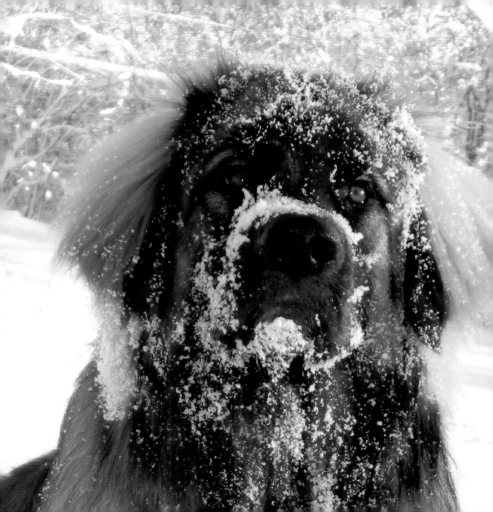

Histories are more full of examples of the **fidelity of dogs** than of friends.

Alexander Pope

I've seen a look in dogs' eyes, a **quickly vanishing** look of amazed contempt, and I am convinced that basically dogs think humans **are nuts**.

John Steinbeck

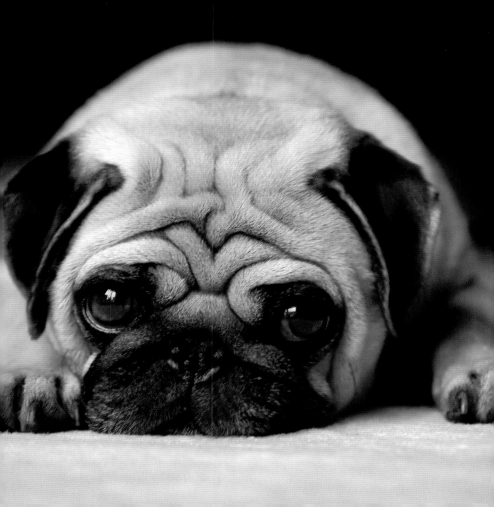

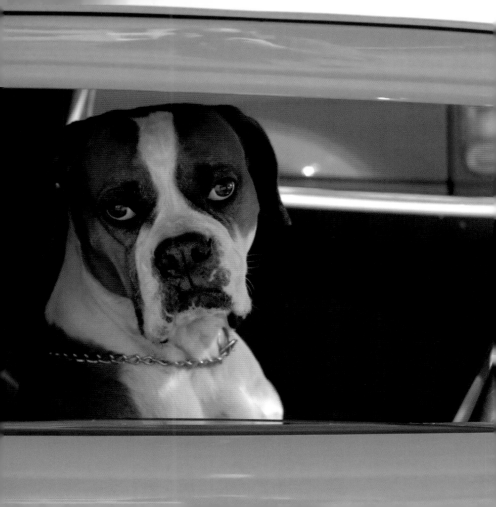

Better not take a dog on the space shuttle, because if he **sticks his head out** when you're coming home his face might burn up.

Jack Handy

What counts is not necessarily the size of the **dog in the fight**; it's the size of the **fight in the dog.**

Dwight D. Eisenhower

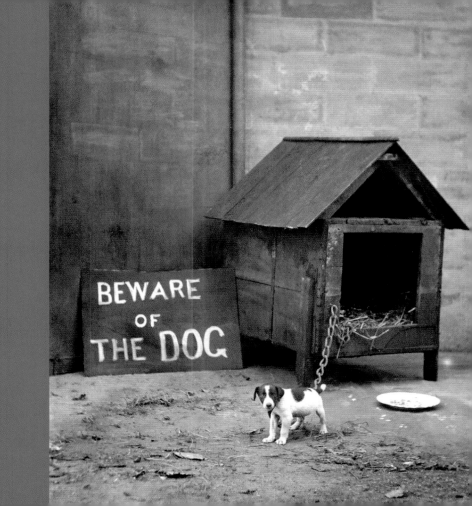

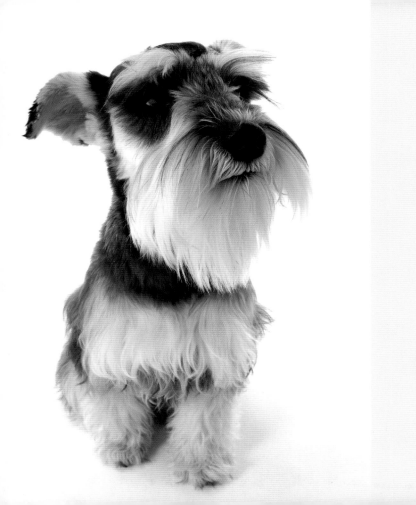

To his dog, **every** man is **Napoleon**; hence the **constant popularity** of dogs.

Aldous Huxley

I think we are drawn to dogs because they are the **uninhibited** creatures we might be if we weren't certain we knew better.

George Bird Evans

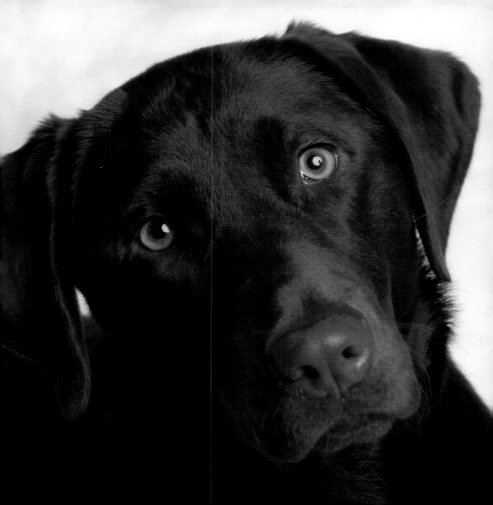

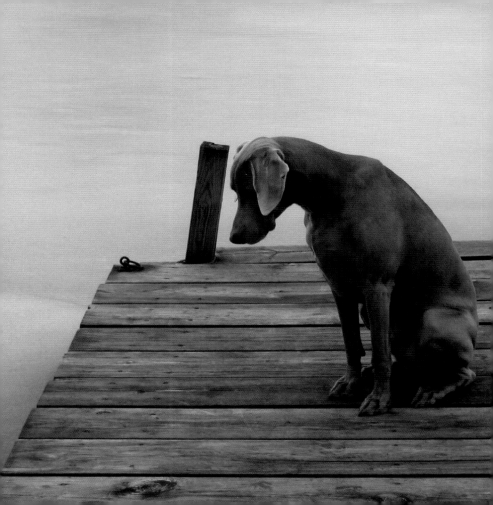

Dogs are wise.

They crawl away into a quiet corner and lick their wounds and do not rejoin the world until they are whole once more.

Agatha Christie

To a dog the **whole world** is a **smell.**

Anonymous

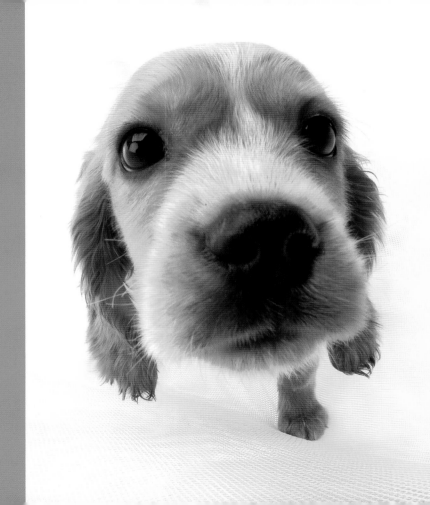

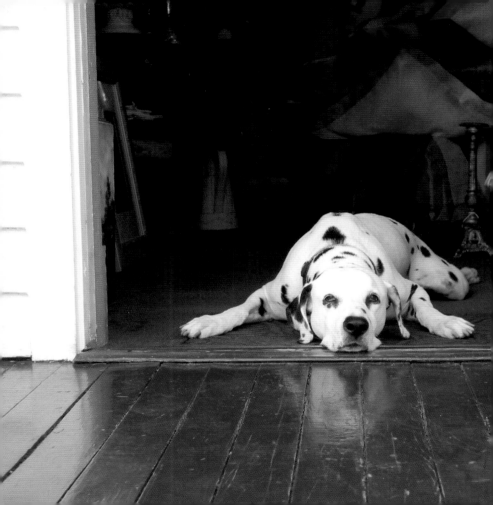

Money will buy you a pretty **good dog,** but it won't buy the **wag** of his tail.

Henry Wheeler Shaw

Did you ever **walk into a room** and forget why you walked in? I think that is how dogs spend their lives.

Sue Murphy

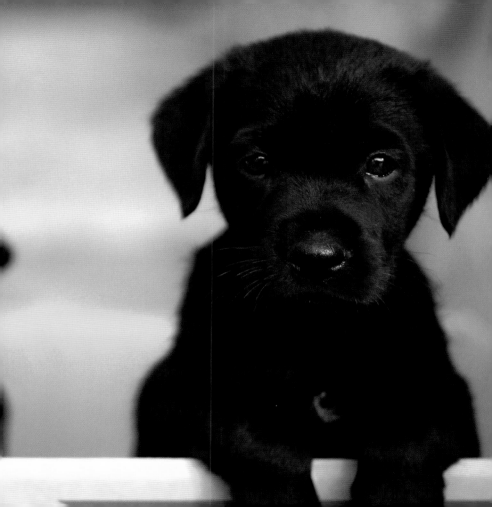

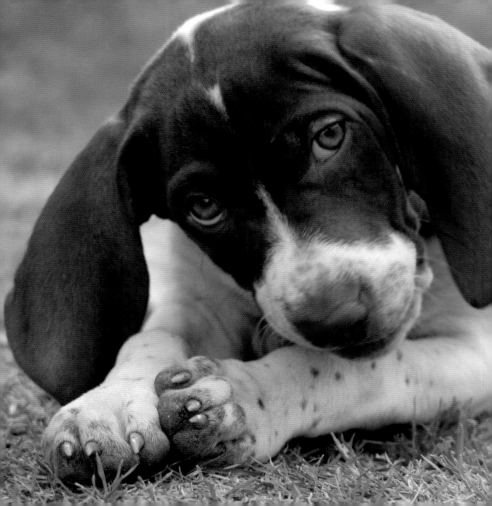

Dogs are not our **whole life**, but they make our **lives whole**.

Roger Caras

Recollect that the Almighty, who gave the dog to be **companion** of our pleasures and our toils, hath invested him with a nature **noble** and **incapable of deceit.**

Sir Walter Scott

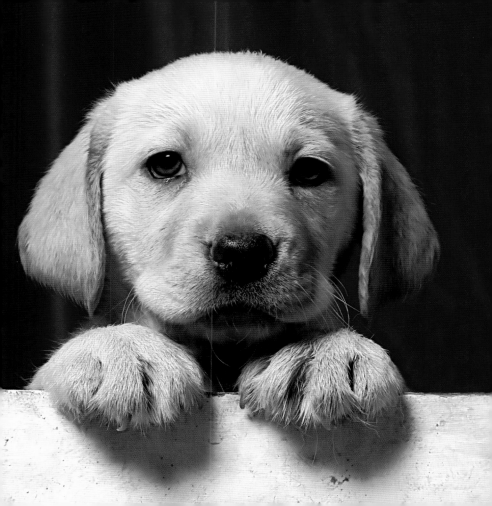

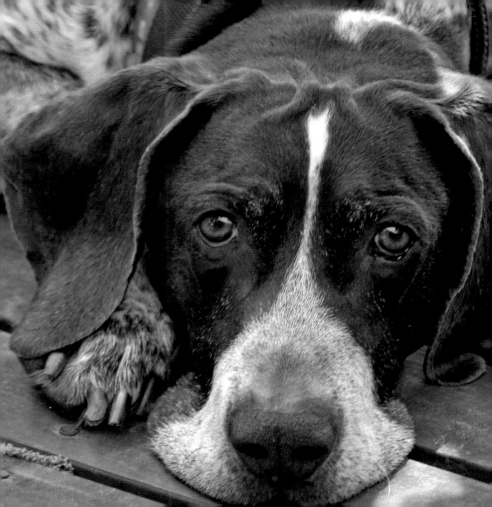

When a **man's best friend** is his dog, that dog has a problem.

Edward Abbey

If it wasn't for dogs, some **people** would never **go** for a walk.

Emily Dickinson

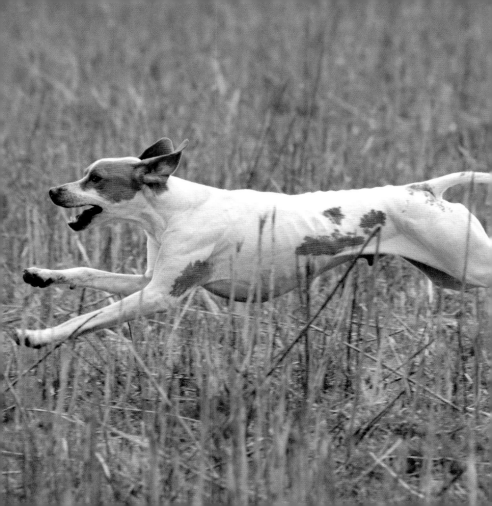

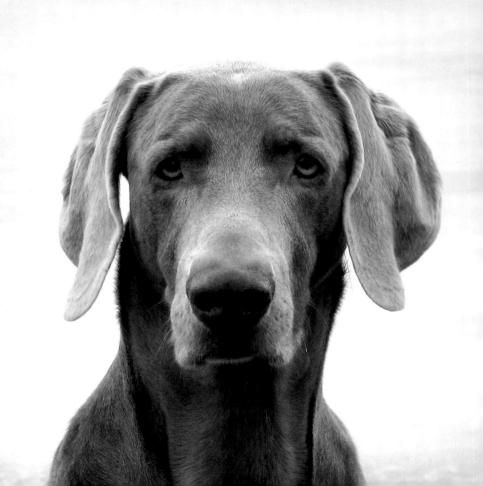

No matter how little money and how **few possessions** you own, having a dog makes you rich.

Louis Sabin

You think dogs will not be in **heaven**? I tell you, they will be there **long before** any of us.

Robert Louis Stevenson

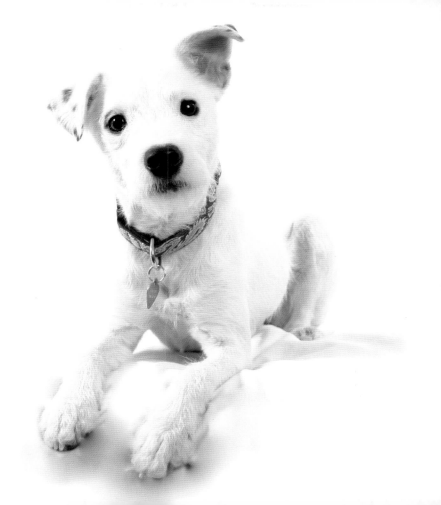

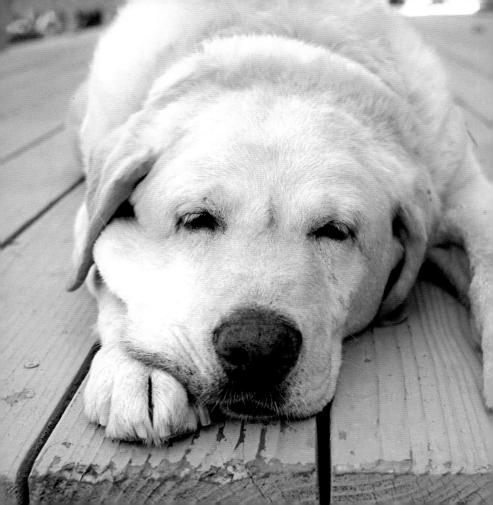

No one **appreciates**
the very **special** genius
of your **conversation**
as the dog does.

Christopher Morley

Our dog **chases people** on a **bike**. We've had to take it off him.

Winston Churchill

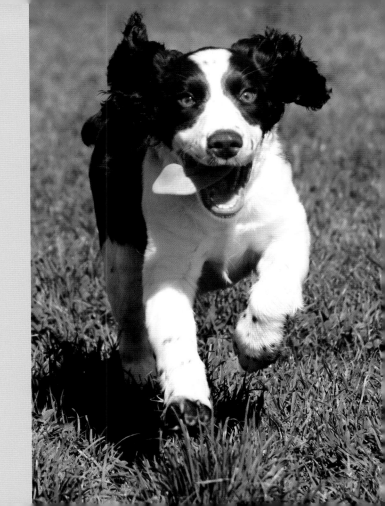

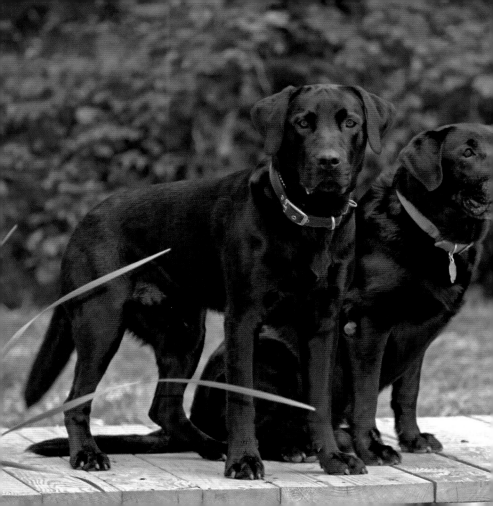

You can say **any fool** thing to a dog, and the dog will give you this **look** that says, 'My God, you're RIGHT! I NEVER would've thought of that!'

Dave Barry

I am I because my **little dog** knows me.

Gertrude Stein

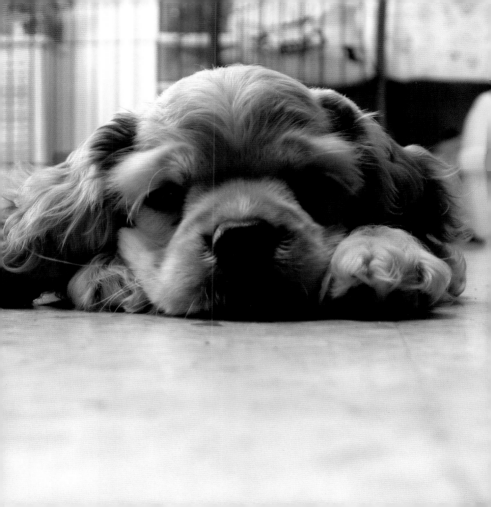

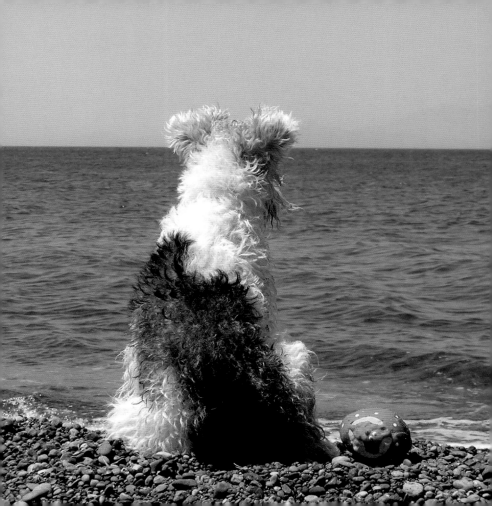

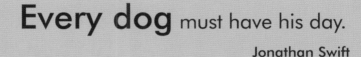

Every dog must have his day.

Jonathan Swift

The **nose** of the bulldog has been slanted backwards so that he can breathe without **letting go**.

Winston Churchill

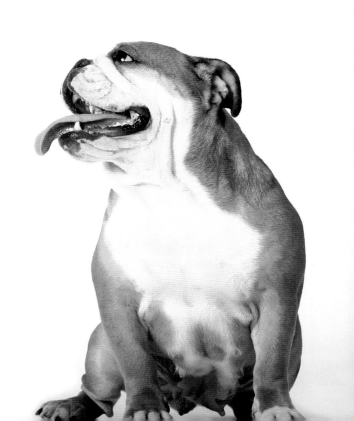

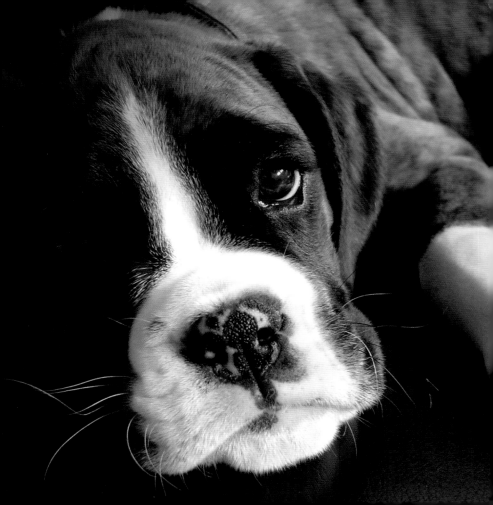

I used to look at [my dog] Smokey and think, 'If you were a **little smarter** you could tell me what you were thinking,' and he'd look at me like he was saying, 'If you were a little smarter, I wouldn't have to.'

Fred Jungclaus

The **greatest pleasure** of a dog is that you may make a **fool** of yourself with him, and not only will he not scold you, but he will make a fool of himself, too.

Samuel Butler

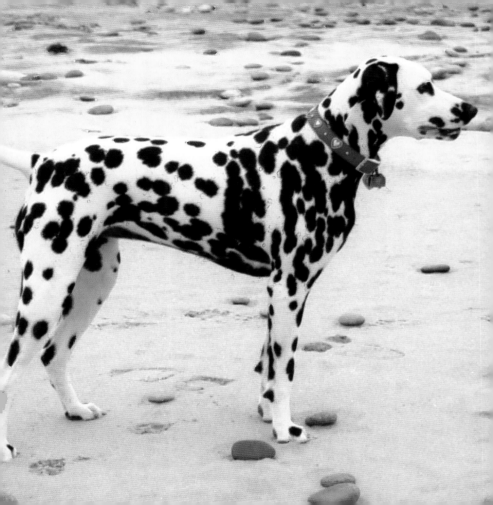

If you get to thinkin' you're a person of some **influence**, try orderin' somebody else's **dog** around.

Cowboy wisdom

The dog was created specially for **children**. He is the god of **frolic**.

Henry Ward Beecher

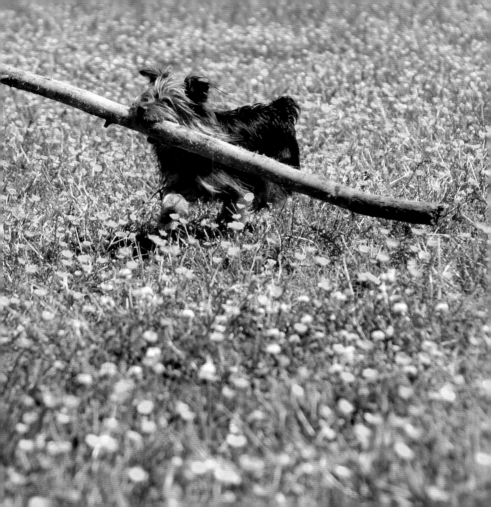

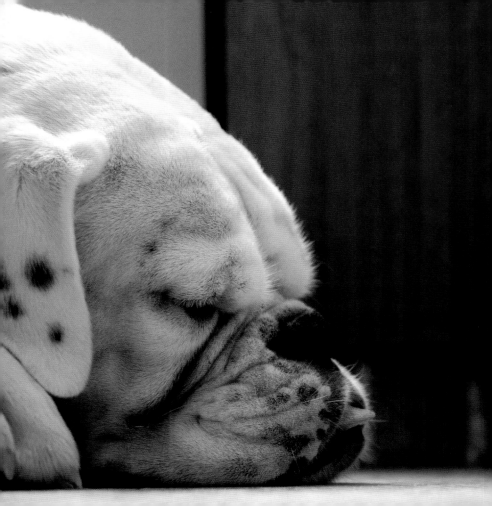

All **knowledge**, the totality of **all questions** and all **answers** is contained in the dog.

Franz Kafka

Scratch a dog and you'll find a **permanent** job.

Franklin P. Jones

Old dogs, like old shoes, are comfortable. They might be a bit out of shape and a **little worn** around the edges, but they **fit well**.

Bonnie Wilcox

Dogs feel **very strongly** that they should always go with you in the car, in case the need should arise for them to **bark violently** at nothing right in your ear.

Dave Barry

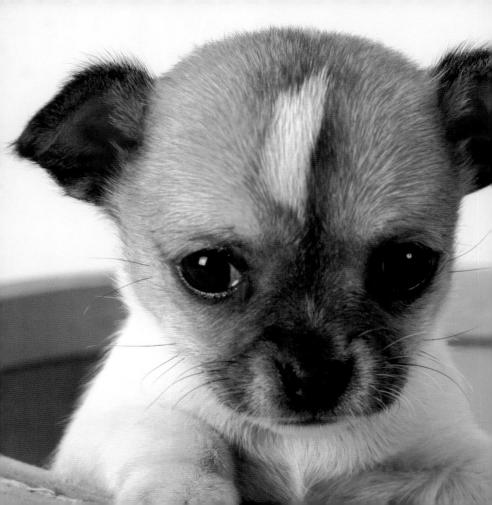

When a dog **wags her tail** and barks at the same time, how do you know **which end** to believe?

Anonymous

If you eliminate **smoking** and gambling, you will be amazed to find that almost all an Englishman's **pleasures** can be, and mostly are, shared by his dog.

George Bernard Shaw

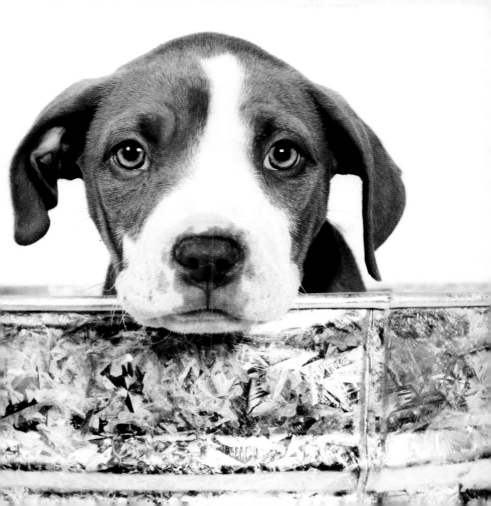

It is nought good a
sleeping hound
wake.

Geoffrey Chaucer

The reason dogs have so many **friends** is because they **wag** their **tails** instead of their tongues.

Anonymous

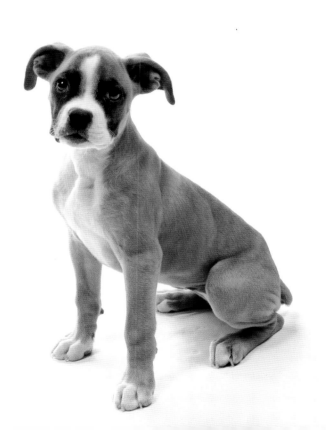

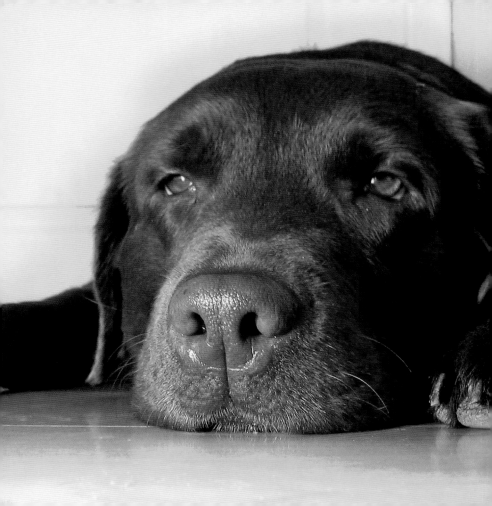

When you feel **dog tired** at night, it may be because you've **growled** all day long.

Anonymous

Whoever said you can't buy **happiness** forgot little **puppies.**

Gene Hill

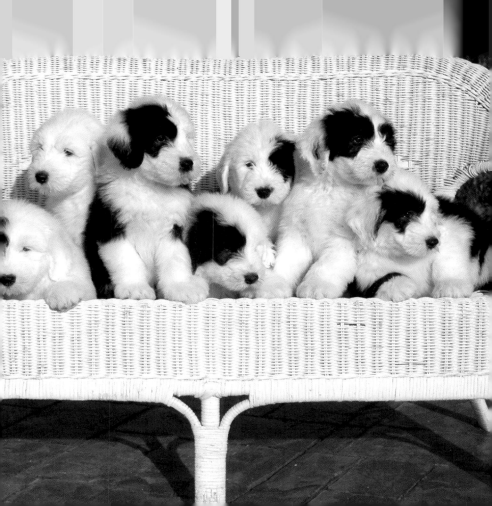

If a dog jumps in your lap, it is because he is **fond** of you; but if a cat does the same thing, it is because your lap is **warmer**.

Alfred North Whitehead

A dog **teaches** a boy fidelity, perseverance, and to **turn around three times** before lying down.

Robert Benchley

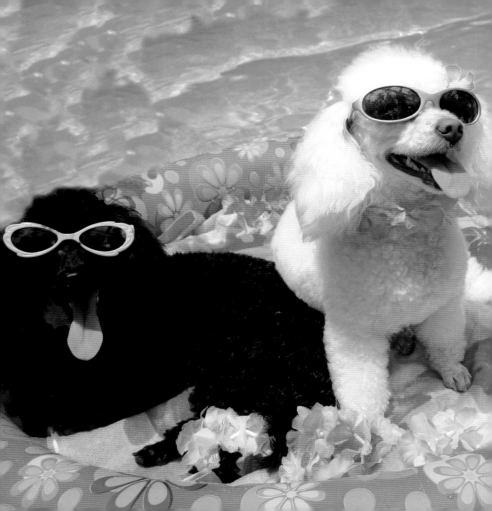

The more I see of the representatives of the **people**, the more I admire my **dogs**.

Alphonse de Lamartine

If you want the best seat in the house... move the dog.

Anonymous

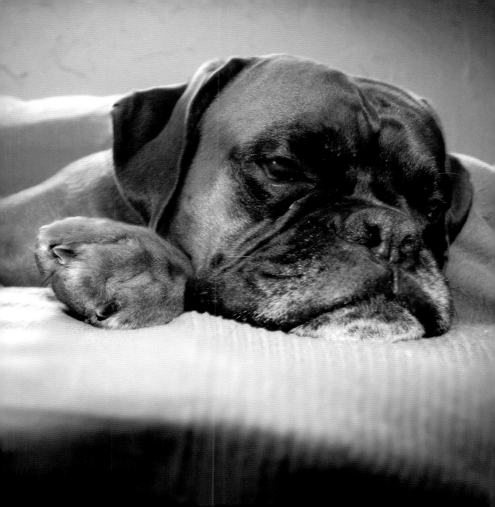

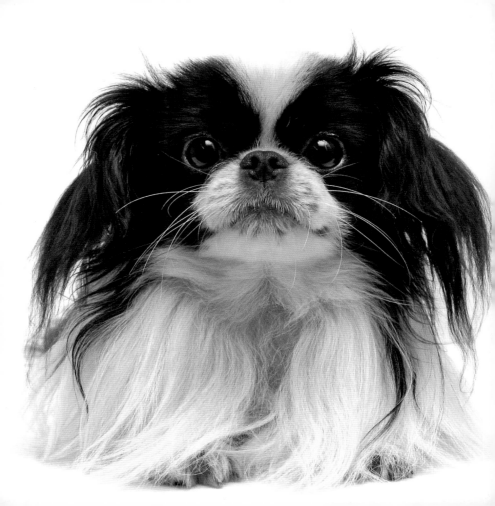

They never talk about themselves but **listen to you** while you talk about yourself, and keep up an appearance of being **interested** in the conversation.

Jerome K. Jerome

My dog is usually **pleased** with what I do, because she is not infected with the concept of what I should be doing.

Lonzo Idolswine

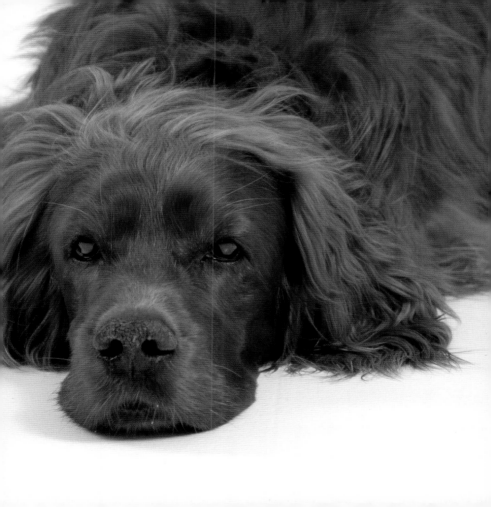

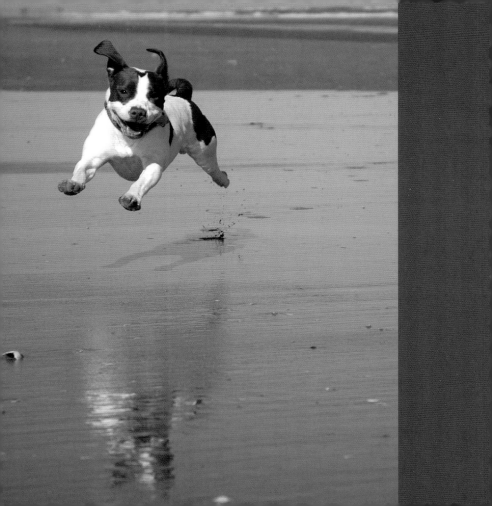

The most **affectionate** creature in the world is **a wet dog.**

Ambrose Bierce

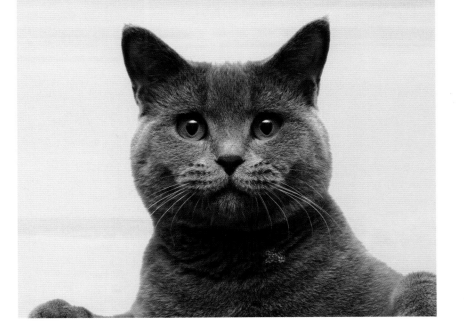

Quotable Cats

Quotable Cats

£5.99

ISBN: 1-84024-536-0
ISBN: 978-1-84024-536-3

Thousands of years ago, cats were worshipped as gods. Cats have never forgotten this.

Anonymous

A beautiful photographic book with quotes about cats, this delightful celebration of the world's favourite furry friend is the purrfect gift for every cat-lover.

www.summersdale.com